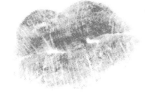

A KISS IS JUST A KISS

A KISS IS JUST A

BRUCE VELICK

INTRODUCTION BY TOM ROBBINS

DESIGN BY JOHN FONTANA

HARMONY BOOKS · NEW YORK

Letterforms by Tom Carnase

Kisses courtesy of Rosemary Caputo

Copyright © 1990 by Bruce Velick

Introduction copyright © 1990 by Tom Robbins

Published by Harmony Books, a division of Crown Publishers, Inc.,
201 East 50th Street, New York, New York 10022

HARMONY and colophon are trademarks of Crown Publishers, Inc.

Manufactured in West Germany

Library of Congress Cataloging-in-Publication Data
A Kiss is just a kiss/[compiled] by Bruce Velick.
1. Photography, Artistic. 2. Kissing in art. I. Velick, Bruce.
TR654.K4935 1990
779'.9394—dc20
89-11134
ISBN 0-517-57511-6

10 9 8 7 6 5 4 3 2 1

First Edition

To Mom . . . a special kiss for all her love and support.

And to Denise . . . whom I hope to share kisses with forever.

X X X

K **I S S I N G** is our greatest invention.

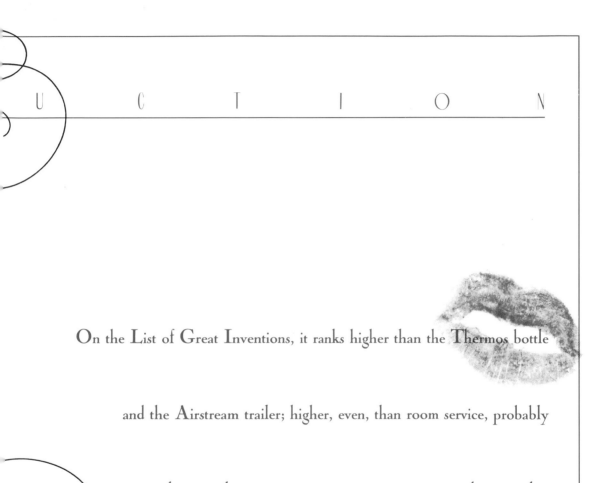

On the List of Great Inventions, it ranks higher than the Thermos bottle

and the Airstream trailer; higher, even, than room service, probably

because the main reason room service was created was so that

people could stay in bed and kiss without starving.

Mirrors are a marvelous invention as well, yet their genesis didn't exactly require a truckload of imagination, the looking glass being merely an extension of pond surface, made portable and refined. Kissing, on the other hand, didn't imitate nature so much as it restructured it. Kissing molded the face into a new shape called the "pucker," and then, like a renegade fruit welder soldering scoops of muskmelon to halves of cherry, it combined puckers. Made them compatible. Interchangeable. Malleable. And animated them. Thomas Edison, turn off your dim bulb and take a hike! Tradition informs us that kissing, as we know it, was invented by medieval knights for the utilitarian purpose of determining whether their wives had been tapping the mead barrel while the knights were away on Crusades. If history is accurate (for once), then the kiss began as an osculatory wiretap, an oral snoop, a kind of alcoholic chastity belt, after the fact. Form is not always faithful to function, however, and eventually kissing for kissing's sake became popular in the courts,

spreading to the tradesmen, peasants, and serfs. And why not? For kissing is fun and kissing is sweet. It was as if all the atavistic sweetness remaining in civilized, Christianized, Western man was funneled into kissing and kissing alone.　　　Kissing is the supreme achievement of the *Western* world. Orientals, including those who tended the North American continent before the land-developers arrived from Europe in the sixteenth century, rubbed noses, and millions still do. Yet, despite the golden cornucopia of their millennia— they gave us yoga and gunpowder, Buddha and pasta—they, their multitudes, their saints and sages, never produced a kiss. (Modern Asians have taken up kissing much as they've taken up the fork, although so far they haven't improved upon it as they usually do with the things they adopt.)　　　Kissing is the flower of the *civilized* world. So-called primitives, savages, pygmies, and cannibals have shown tenderness to one another in many tactile ways, but pucker against pucker has not been their style. Tropical Africans

touched lips, you say? Quite right, many of them did, as did certain aboriginal peoples in other parts of the world. Ah, but though their lips may have touched, they did not linger. And the peck is a square wheel, inchoate and slightly ominous. With what else did Judas betray Our Savior but a peck: terse, spit-free, and tongueless?　　　　　Kissing is the glory of the *human* species. All animals copulate, but only humans kiss. Parakeets rub beaks? Sure they do, but only those little old ladies who murder schoolchildren with knitting needles to steal their lunch money so that they can buy fresh kidneys for kittycats could place bird-billing in the realm of the true kiss. There are primatologists who claim that apes exchange oral affection, but from here the sloppy smacks of chimps look pretty rudimentary: They're probably just checking to see if their mates have been into the fermented bananas. No, random beast-to-beast snout friction may give narrators of wildlife films an opportunity to plumb new depths of anthropomorphic cuteness, but it doesn't

cut the cherub-flavored mustard in the osculation department.

Psychologists claim that talking to pets is a socially acceptable excuse for talking to ourselves. That may say something interesting about those of you who kiss your pets, but you shouldn't let it stop you. Smooch your bulldog if you're so inclined. Buss your sister, your brother, your grandpa, and anybody's bouncing baby. No kiss is ever wasted, not even on the winless lottery ticket kissed for luck. Kiss trees. Favorite books. Bowling balls. Old Jews sometimes kiss their bread before eating it, and those are good kisses too. They resonate in the ether. The best kisses, though, are those between lovers, because those are the consequential ones, the risky ones, the transformative ones, the ones that call the nymphs and satyrs back to life, the many-layered kisses that we dive into as into a fairy-tale frog pond or the warm whirlpool of our origins. The fact that we enjoy watching others kiss is probably some sort of homing instinct. In any case, it explains the popular appeal of

Hollywood and Paris. Who can forget the elastic thread of saliva that for one brief but electrifying second connected Yvonne DeCarlo to Dan Duryea in *Black Bart*? And Joni Mitchell's line, "In France, they kiss on Main Street," set thousands of the romantically fascinated to packing their bags for Orly. Perhaps some of the photographers in this book were among them. Perhaps not. Nevertheless, in the best tradition of aesthetic voyeurism, each has kept his or her superb eye peeled for the kissers of the world, and many of them have successfully captured that strange galactic light that surrounds all those "who doth embrace." Ansel Adams's genius camera may have celebrated landscape, but, ultimately, what good are mountains and moons except as backdrops for lovers—and where would lovers be without the kiss? No other flesh like lip flesh! No meat like mouth meat! The musical clink of tooth against tooth! The wonderful curiosity of tongues!

—*Tom Robbins*

^ 1. William Mortensen

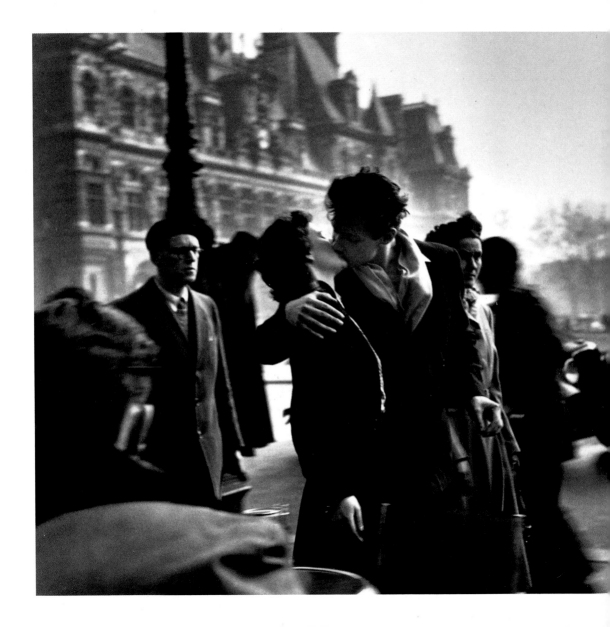

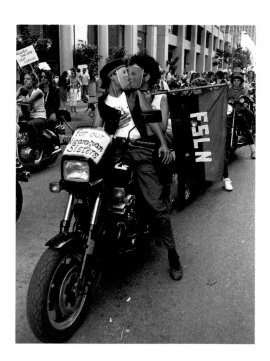

< 2. Robert Doisneau

∧ 3. Cathy Cade

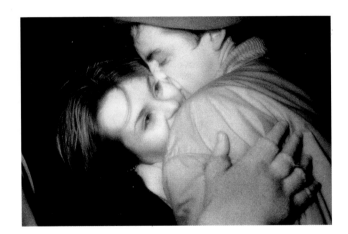

∧ 4. Peter Marlow

> 5. Bruce Davidson

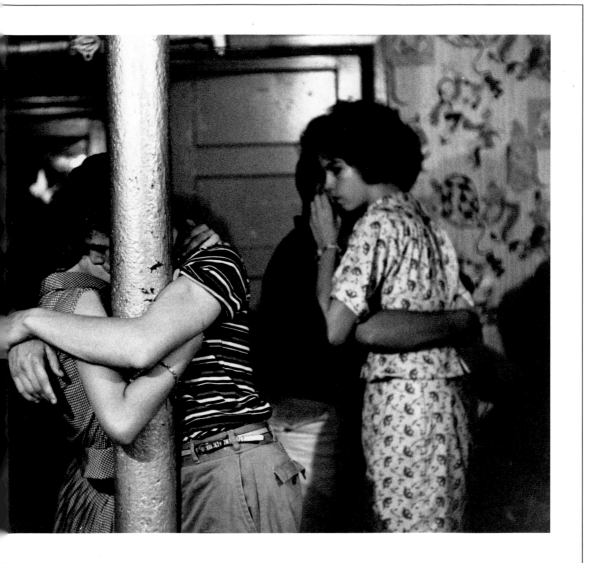

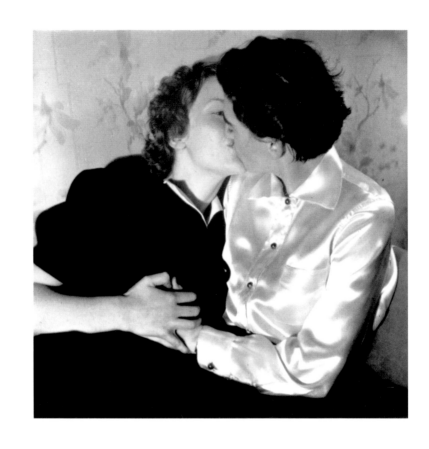

∧ 6. John Gutmann

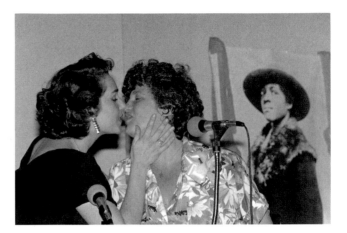

7. JEB/Joan E. Biren >

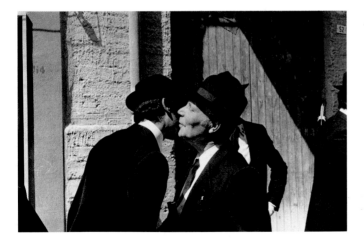

< 8. Ferdinando Scianna

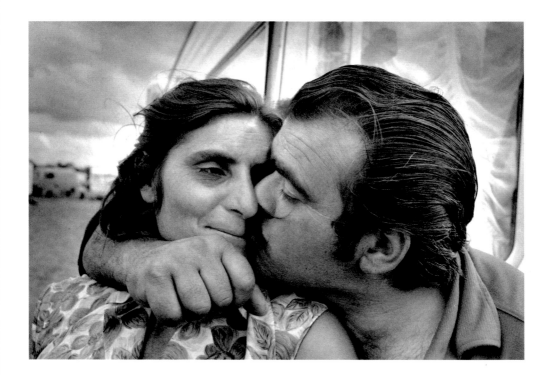

^ 9. Jean Gaumy

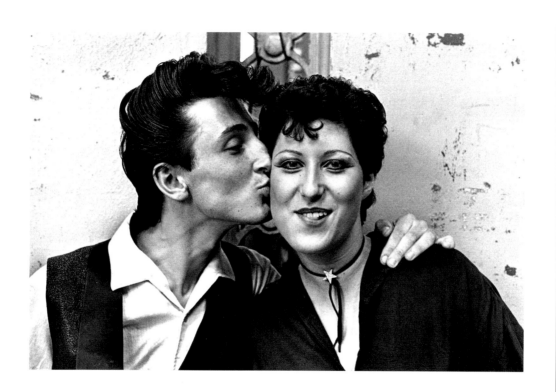

^ 10. Chris Steele-Perkins

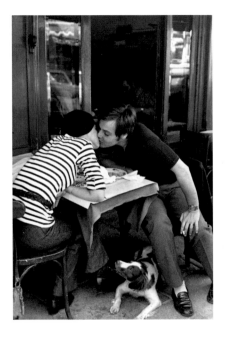

^ 11. Henri Cartier-Bresson

12. Joan Moss >

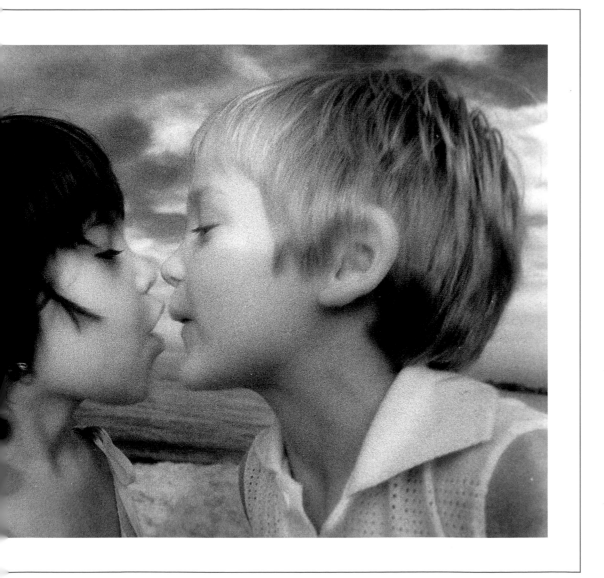

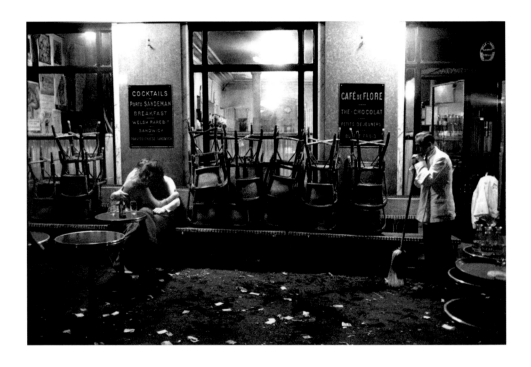

∧ 13. Dennis Stock

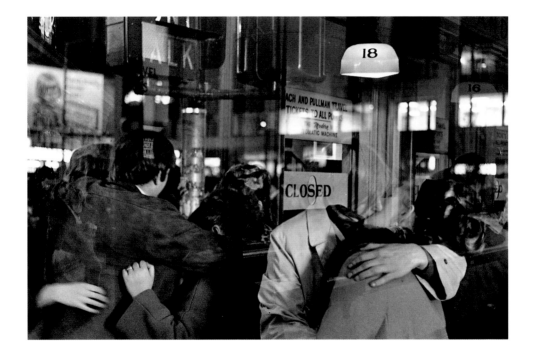

∧ 14. Leonard Freed

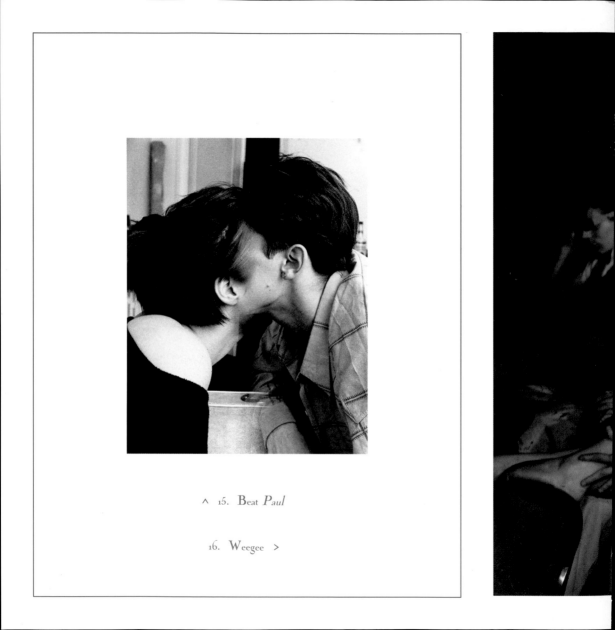

∧ 15. Beat *Paul*

16. Weegee >

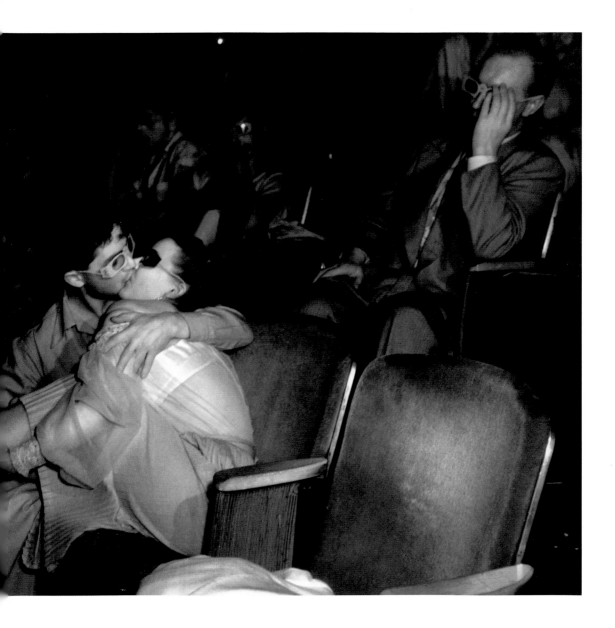

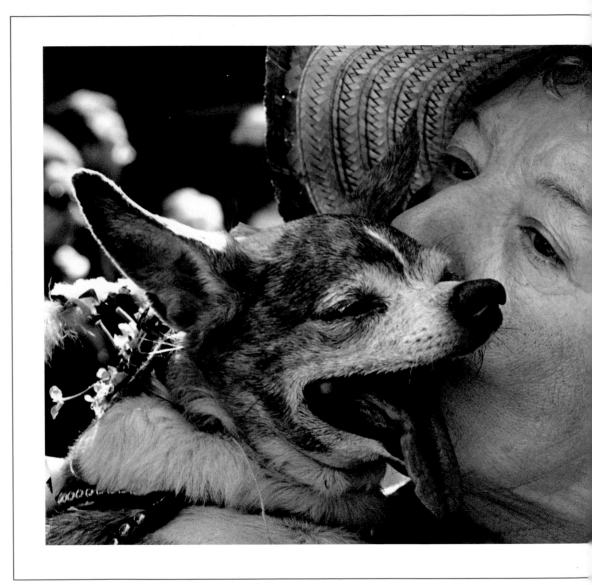

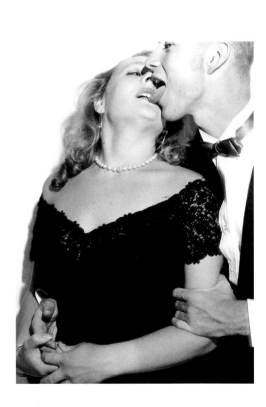

< 17. Elliott Erwitt

∧ 18. Ken Miller

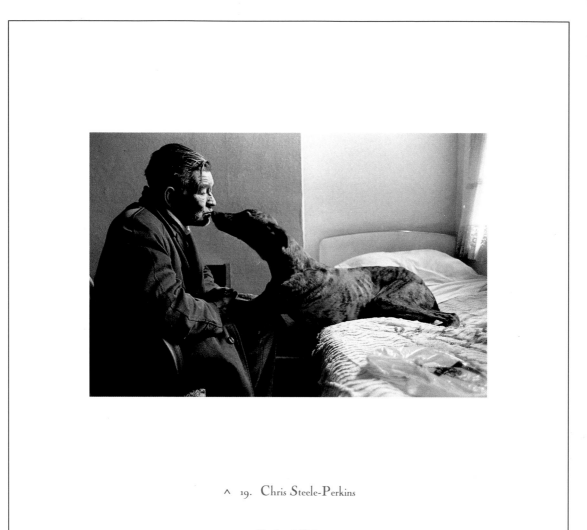

∧ 19. Chris Steele-Perkins

20. Richard Kalvar >

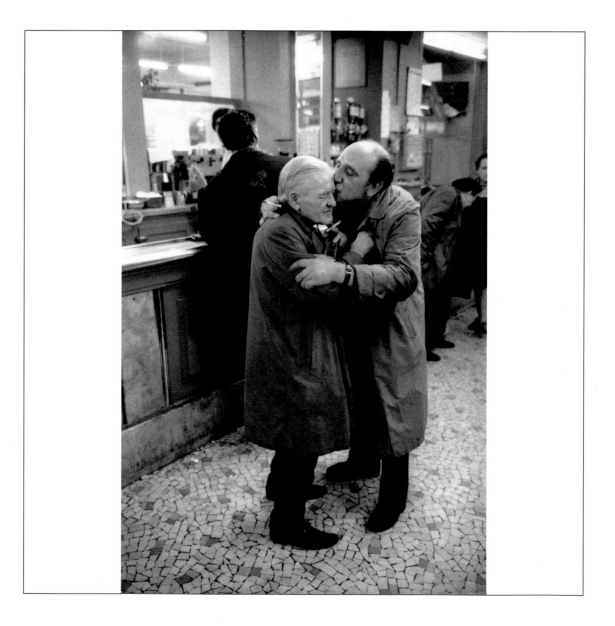

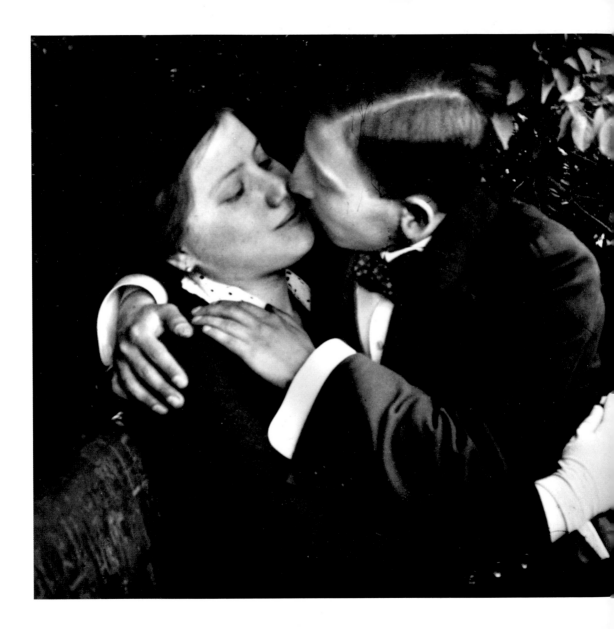

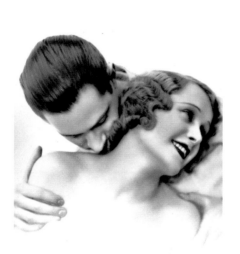

Le baiser est le don sans retour de soi-même,
La première caresse et le geste suprême.

PC
3656

< 21. André Kertész

∧ 22. Photographer unknown

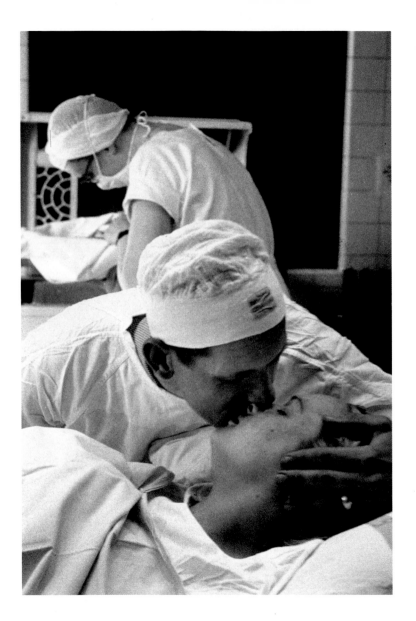

< 23. Burt Glinn

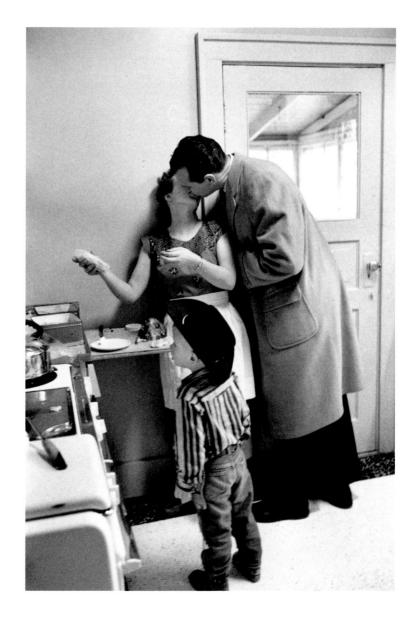

24. Carl Iwasaki >

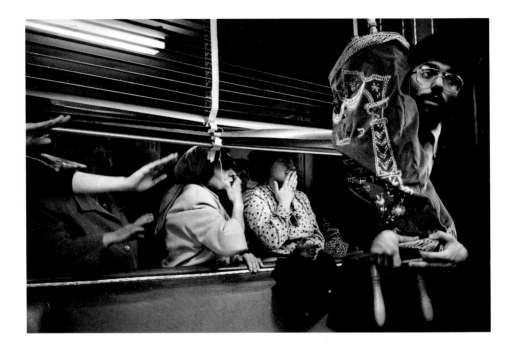

∧ 25. Patrick Zachmann

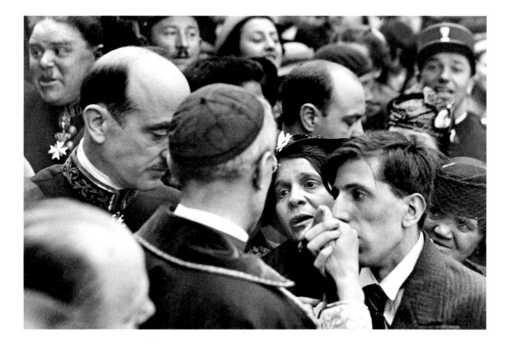

^ 26. Henri Cartier-Bresson

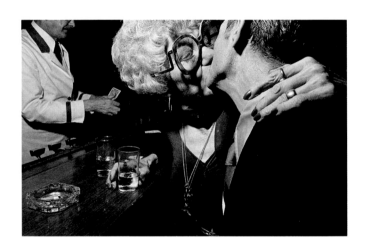

^ 27. Mary Ellen Mark

28. Ernst Haas >

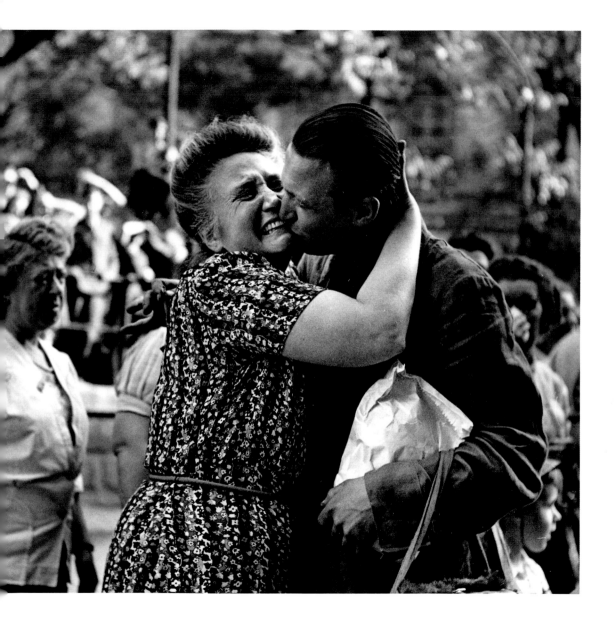

29. Louis Stettner >

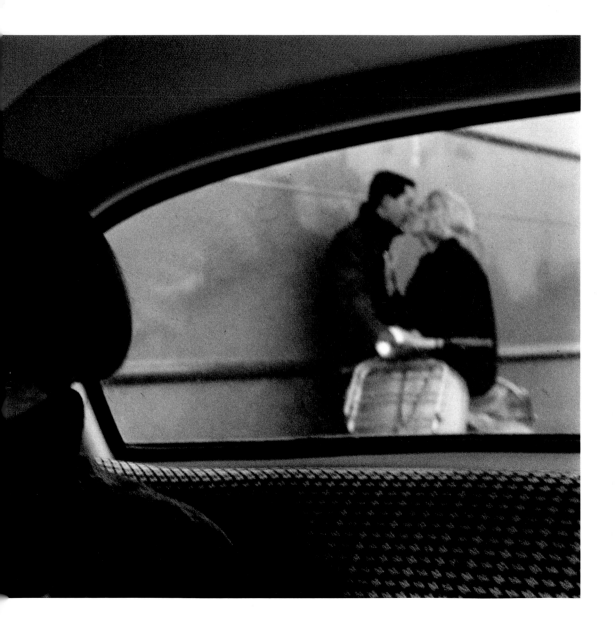

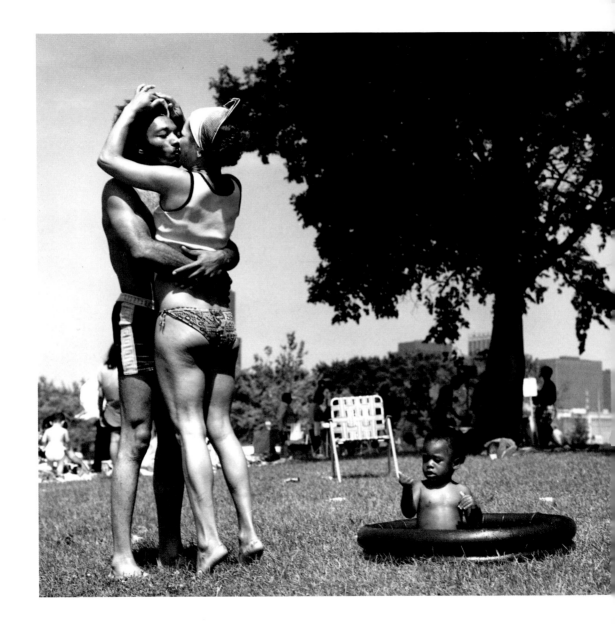

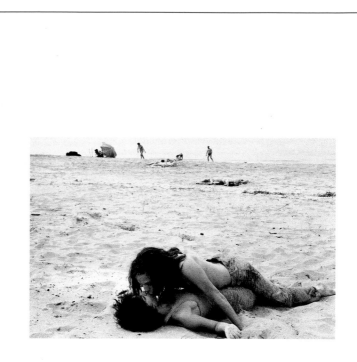

< 30. Barbara Crane

∧ 31. Gilles Peress

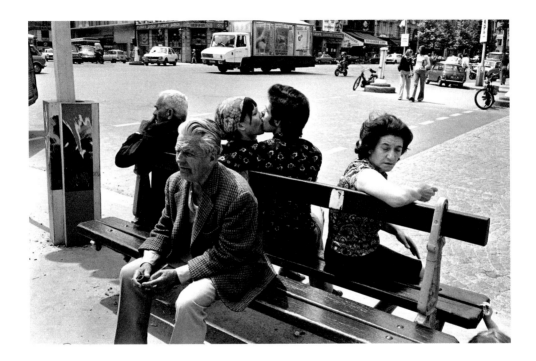

∧ 32. Abbas

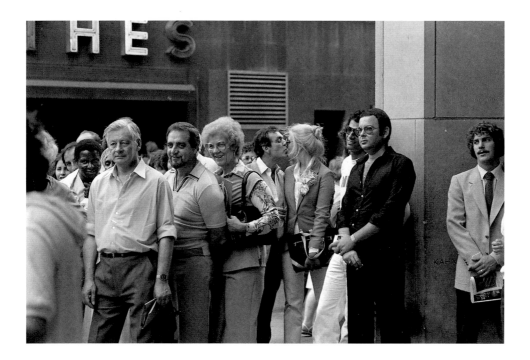

∧ 33. Lou Stoumen

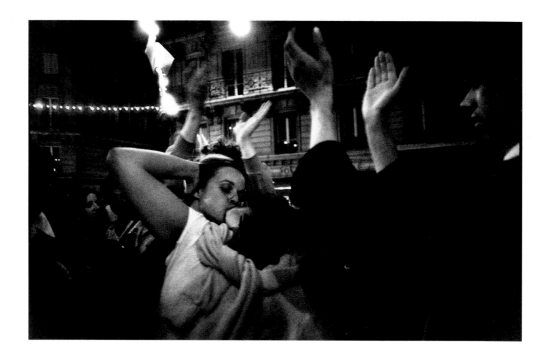

∧ 34. Guy Le Querrec

35. Alfred Eisenstaedt >

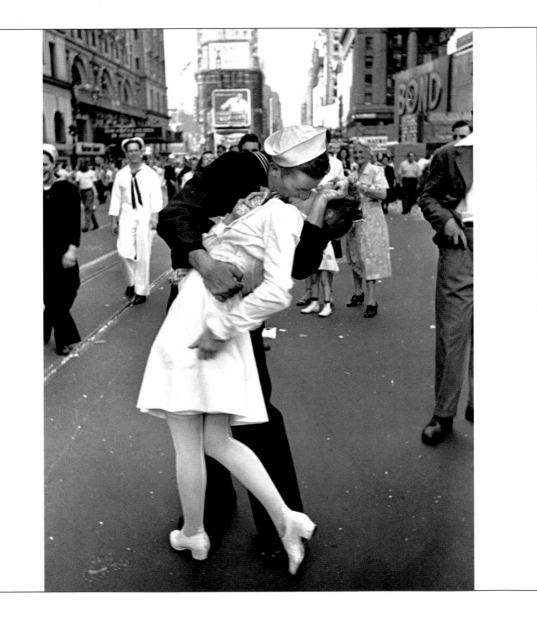

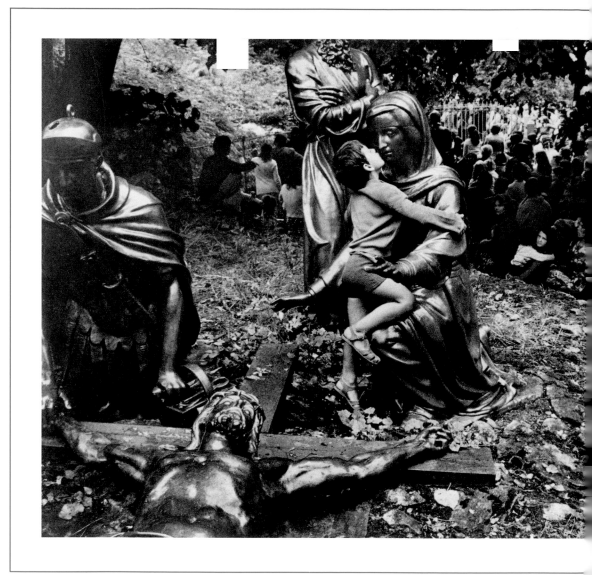

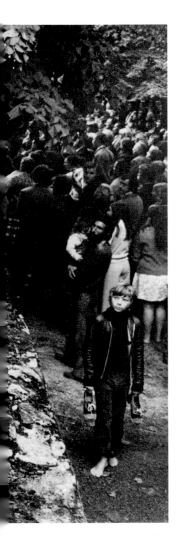

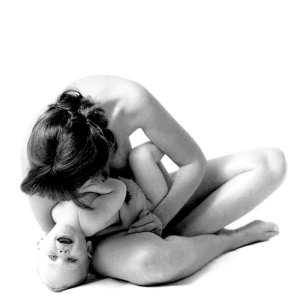

< 36. Josef Koudelka

∧ 37. Julia Parker

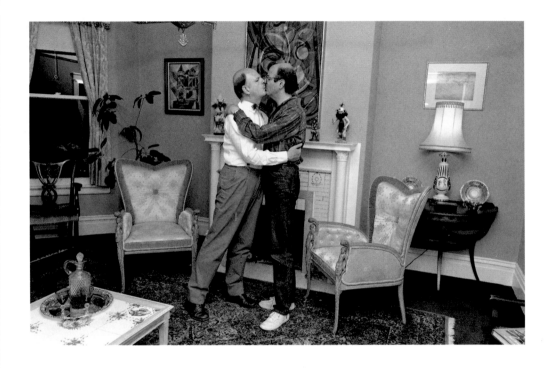

∧ 38. Sage Sohier

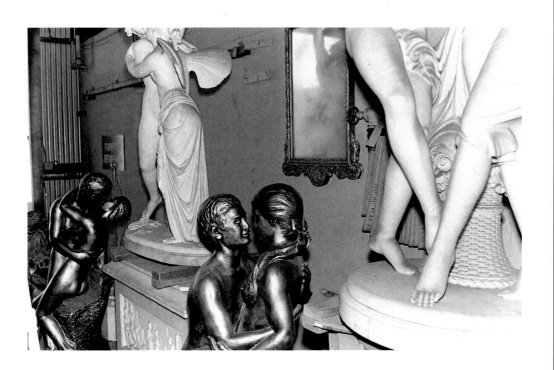

^ 39. Bill Dane

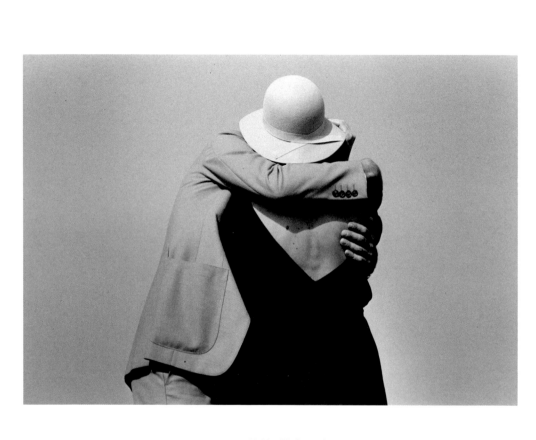

∧ 40. Eddie Kuligowski

41. Wayne Miller ＞

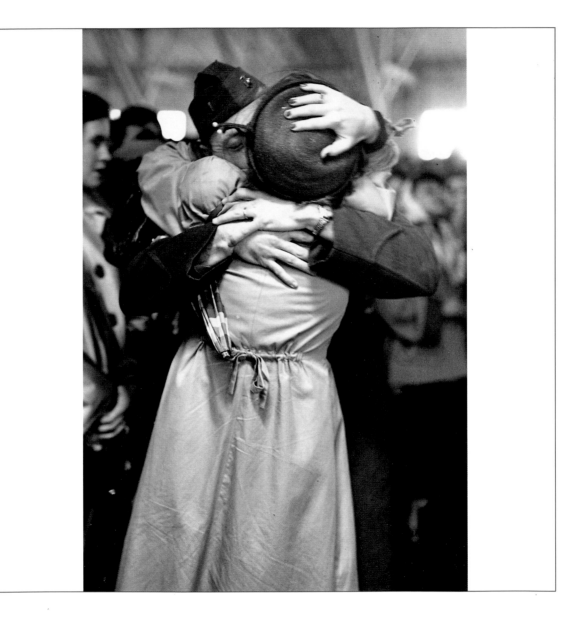

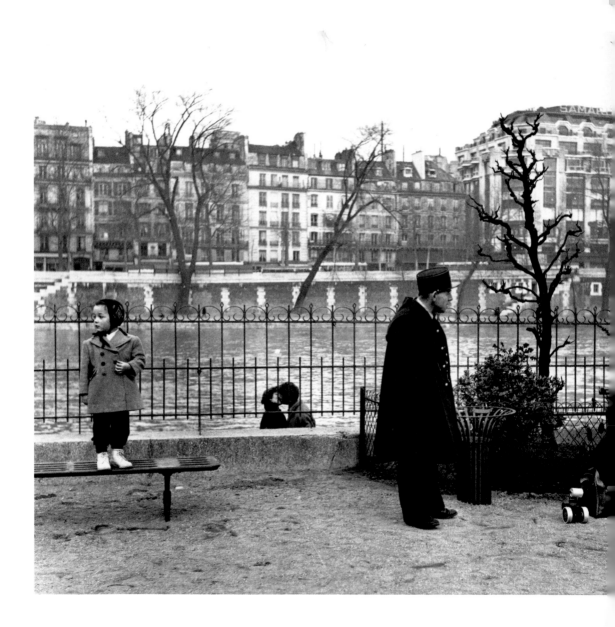

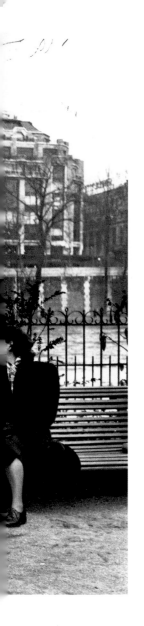

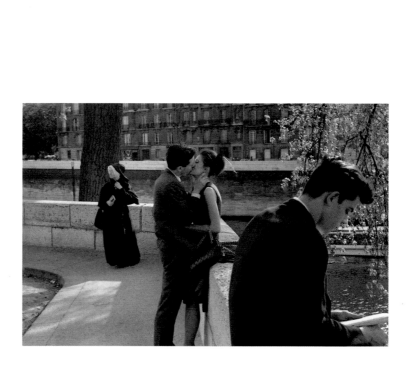

< 42. Robert Doisneau

∧ 43. Edouard Boubat

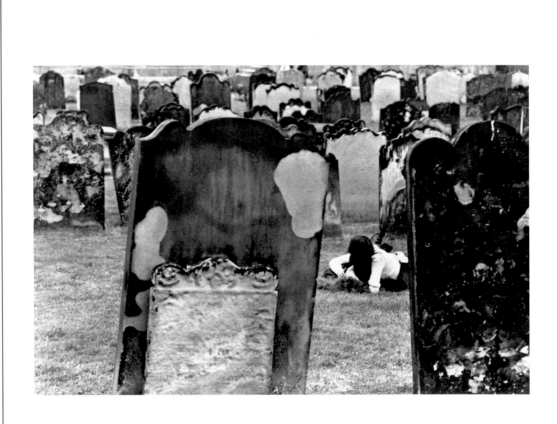

^ 44. Henri Cartier-Bresson

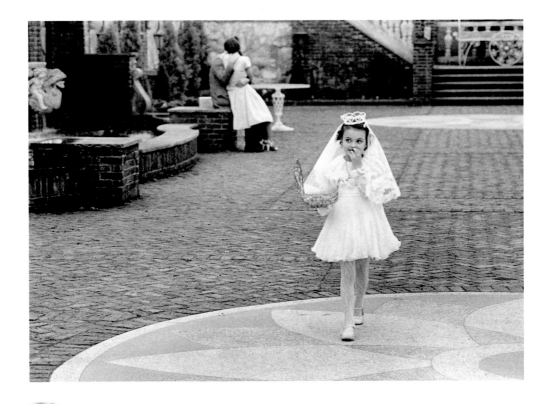

^ 45. Jeffrey Schwarz

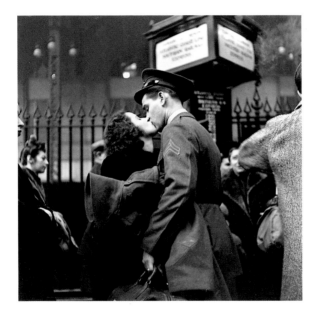

∧ 46. Alfred Eisenstaedt

47. René Burri >

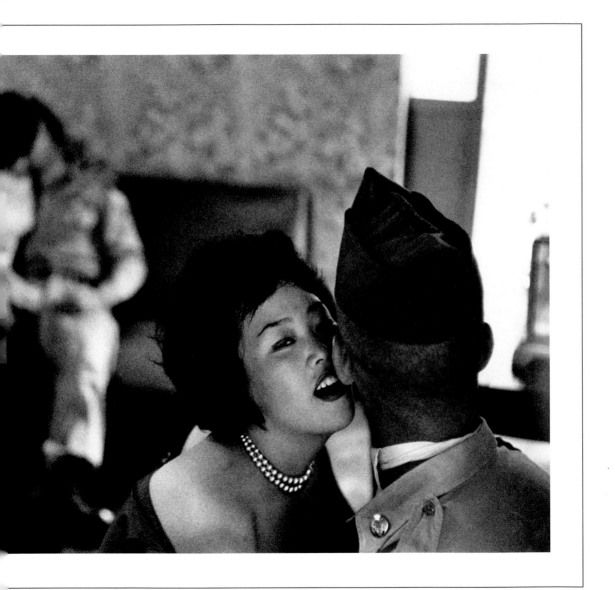

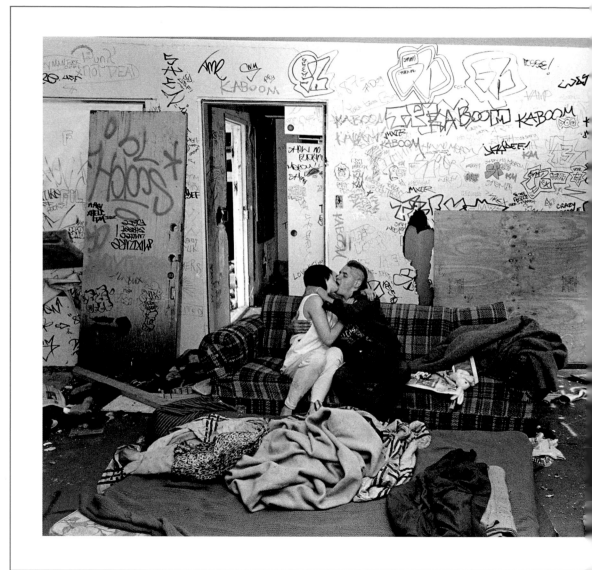

<< 48. Jim Goldberg

49. Helen Levitt >

< 50. Helen Levitt

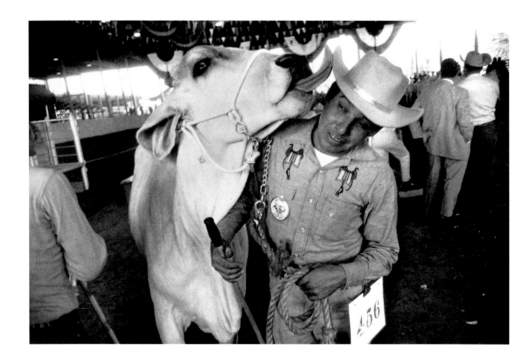

∧ 51. Garry Winogrand

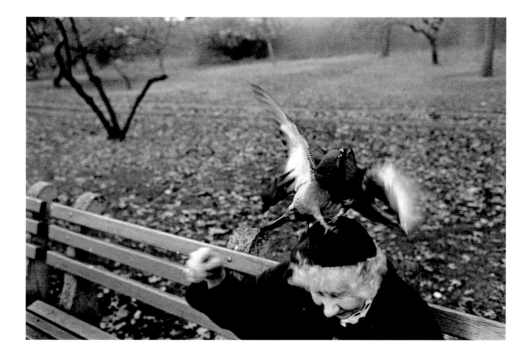

∧ 52. Richard Kalvar

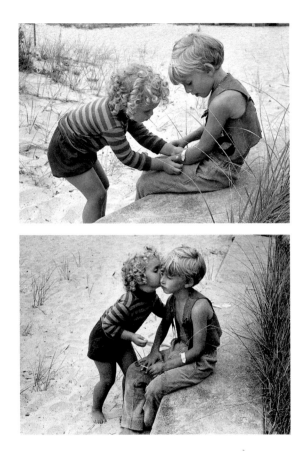

^ 53. Ruth Orkin

54. André Kertész >

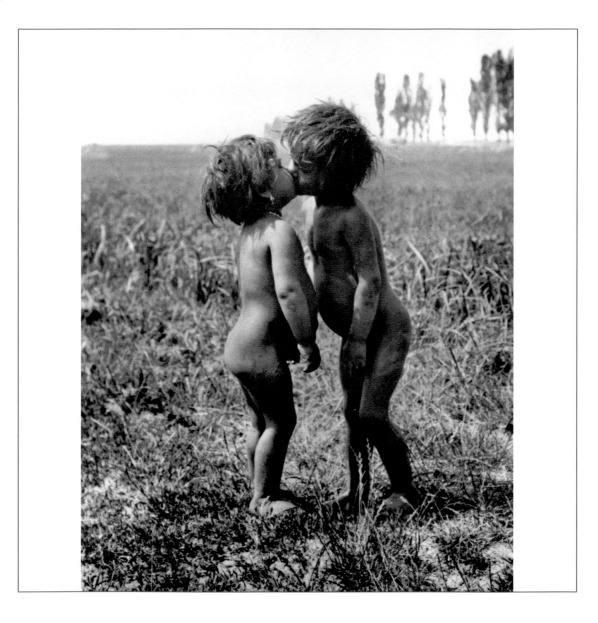

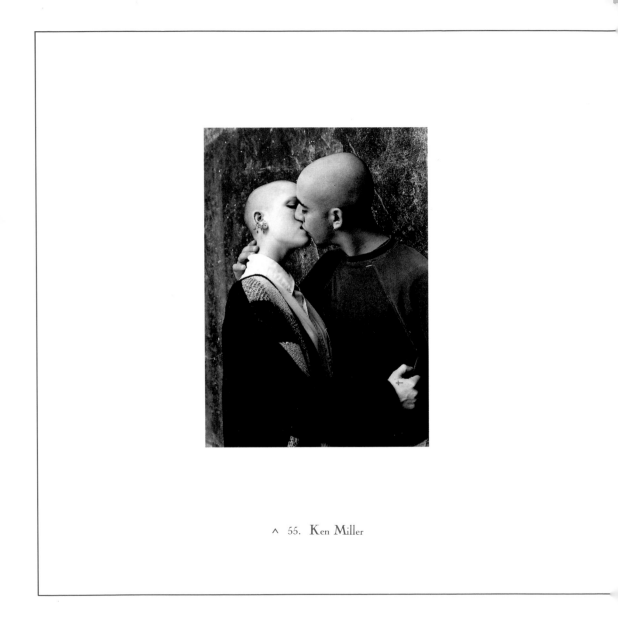

∧ 55. Ken Miller

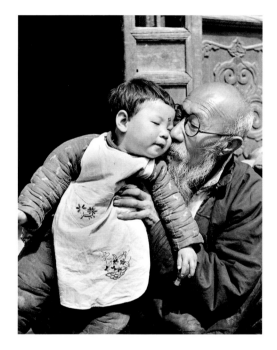

∧ 56. Dmitri Kessel

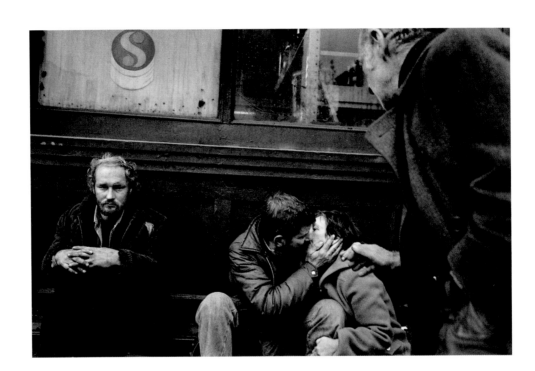

∧ 57. Jean Gaumy

58. Willy Ronis >

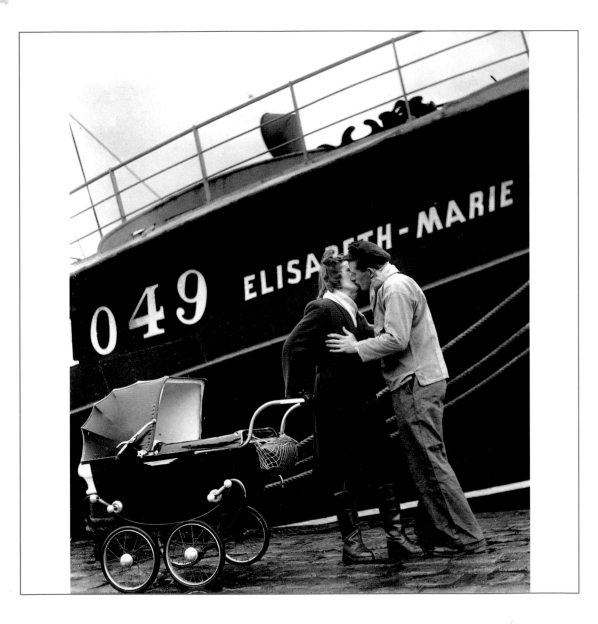

59. Elliott Erwitt >

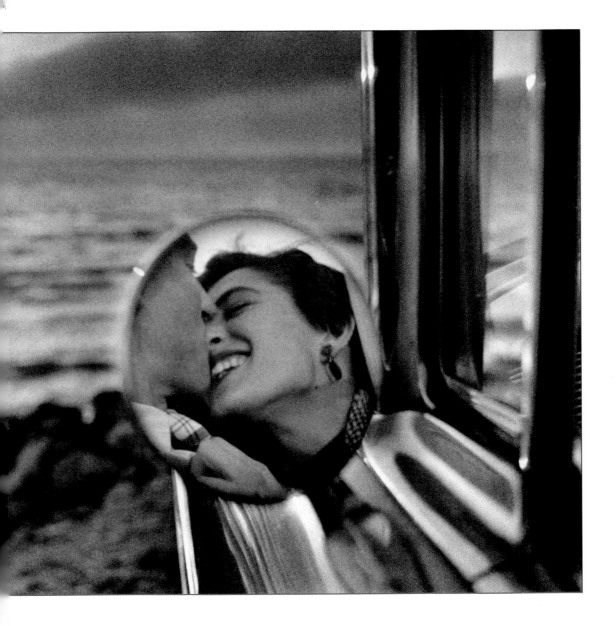

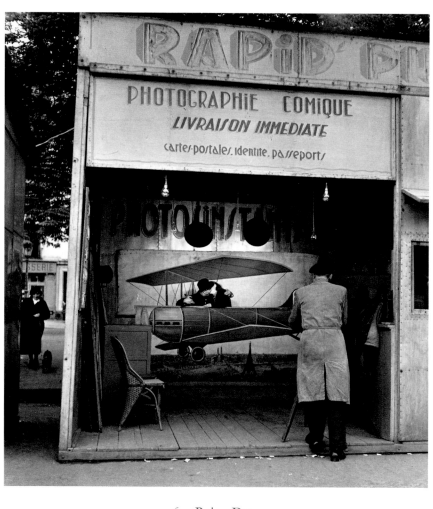

∧ 60. Robert Doisneau

I L L U S T R A T I O N S

1. William Mortensen, *The Kiss,* c. 1926. (© 1989 the Mortensen Estate. Courtesy Paul Hertzman, Inc., and the Mortensen Estate.)

2. Robert Doisneau, *Le Baiser de l'Hotel de Ville,* Paris, 1950. (© Rapho. Courtesy Robert Doisneau/Rapho and Hyperion Press Limited.)

3. Cathy Cade, *For Our Nicaraguan Sisters,* San Francisco, 1986. (© 1986 Cathy Cade. Courtesy the photographer.)

4. Peter Marlow, Untitled, n.d. (© Peter Marlow. Courtesy Peter Marlow/Magnum.)

5. Bruce Davidson, *The Gang, #2,* Paris, 1956. (© 1956 Bruce Davidson. Courtesy Bruce Davidson/Magnum.)

6. John Gutmann, *Two Women in Love,* 1937. (© 1988 John Gutmann. Courtesy Fraenkel Gallery, San Francisco.)

7. JEB/Joan E. Biren, *Claire and Joan at the Lesbian History Archives 10th Anniversary,* 1987. (© 1987 JEB/Joan E. Biren. Courtesy the photographer.)

8. Ferdinando Scianna, Untitled, Italy, 1982. (© 1982 Ferdinando Scianna. Courtesy Ferdinando Scianna/Magnum.)

9. Jean Gaumy, Untitled, n.d. (© Jean Gaumy. Courtesy Jean Gaumy/Magnum.)

10. Chris Steele-Perkins, *Teds—Alexandra Palace,* London, n.d. (© Chris Steele-Perkins. Courtesy Chris Steele-Perkins/Magnum.)

11. Henri Cartier-Bresson, Untitled, U.S.A., n.d. (© Henri Cartier-Bresson. Courtesy Henri Cartier-Bresson/Magnum.)

12. Joan Moss, from "Mothers and Their Children" portfolio, 1981. (© 1981 Joan Moss. Courtesy Catherine Edelman Gallery, Chicago.)

13. Dennis Stock, Untitled, France, 1958. (© 1958 Dennis Stock. Courtesy Dennis Stock/ Magnum.)

14. Leonard Freed, *Grand Central Station,* New York, 1969. (© 1969 Leonard Freed. Courtesy Leonard Freed/Magnum.)

15. Beat *Paul, Le Couple,* 1987. (© 1987 Beat *Paul.* Courtesy the photographer.)

16. Weegee, *The Palace Theater,* New York, 1945. (© Weegee. Courtesy Wilma Wilcox, the Weegee Collection.)

17. Elliott Erwitt, Untitled, 1968. (© 1968 Elliott Erwitt. Courtesy Elliott Erwitt/Magnum.)

18. Ken Miller, *Debutante Ball,* 1986. (© 1987 Ken Miller. Courtesy Harrison Sheppard.)

19. Chris Steele-Perkins, Untitled, England, 1978. (© 1978 Chris Steele-Perkins. Courtesy Chris Steele-Perkins/Magnum.)

20. Richard Kalvar, Untitled, France, 1974. (© 1974 Richard Kalvar. Courtesy Richard Kalvar/ Magnum.)

21. André Kertész, *Lovers,* Budapest, 1915. (© 1989 Estate of André Kertész. Courtesy the Estate of André Kertész.)

22. Photographer and date unknown.

23. Burt Glinn, *Mr. Jones Has a Baby,* U.S.A., 1955. (© 1955 Burt Glinn. Courtesy Burt Glinn/Magnum.)

24. Carl Iwasaki, *Sheriff with Family, Denver, Colorado,* n.d. (Courtesy *Life* magazine/© Time Inc.)

25. Patrick Zachmann, Untitled, n.d. (© Patrick Zachmann. Courtesy Patrick Zachmann/ Magnum.)

26. Henri Cartier-Bresson, *Kissing the Pope's Ring (Cardinal Pacelli, Montmartre),* 1938. (© 1938 Henri Cartier-Bresson. Courtesy Henri Cartier-Bresson/Magnum.)

27. Mary Ellen Mark, *Roseland,* New York, 1977. (© 1977 Mary Ellen Mark. Courtesy the photographer.)

28. Ernst Haas, Untitled, Austria, 1945. (© 1945 Ernst Haas. Courtesy Ernst Haas/Magnum.)

29. Louis Stettner, *Ferry Crossing,* Holland, c. 1959. (© Louis Stettner. Courtesy the photographer and Hyperion Press Limited.)

30. Barbara Crane, *Chicago Parks and Beaches,* 1972–78. (© 1986 Barbara Crane. Courtesy Catherine Edelman Gallery, Chicago.)

31. Gilles Peress, Untitled, n.d. (© Gilles Peress. Courtesy Gilles Peress/Magnum.)

32. Abbas, Untitled, France, 1973. (© 1973 Abbas. Courtesy Abbas/Magnum.)

33. Lou Stoumen, *The Kiss—Times Square,* New York, 1981. (© 1981 Lou Stoumen. Courtesy the photographer.)

34. Guy Le Querrec, Untitled, France, n.d. (© 1979 Guy Le Querrec. Courtesy Guy Le Querrec/Magnum.)

35. Alfred Eisenstaedt, *V-J Day, Times Square*, New York, 1945. (Courtesy *Life* magazine/ © Time Inc.)

36. Josef Koudelka, Untitled, France, 1973. (© 1973 Josef Koudelka. Courtesy Josef Koudelka/ Magnum.)

37. Julia Parker, *Mother and Child*, 1987. (© 1987 Julia Parker. Courtesy Harrison Sheppard.)

38. Sage Sohier, *Lloyd and Joel*, San Francisco, 1987. From Gay Couples Project. (© 1987 Sage Sohier. Courtesy the photographer.)

39. Bill Dane, *Universal Studios*, Los Angeles, 1974. (© Bill Dane. Courtesy the photographer.)

40. Eddie Kuligowski, *Le Couple*, 1978. (© 1978 Eddie Kuligowski. Courtesy the photographer.)

41. Wayne Miller, *Marines Returning from Korea*, 1951. (© 1951 Wayne Miller. Courtesy Wayne Miller/Magnum.)

42. Robert Doisneau, *Au Square du Vert Galant*, 1950. (© Rapho. Courtesy Robert Doisneau/ Rapho and Hyperion Press Limited.)

43. Edouard Boubat, *L'ile Saint-Louis*, Paris, 1975. (© Rapho. Courtesy Edouard Boubat/ Rapho and Hyperion Press Limited.)

44. Henri Cartier-Bresson, Untitled, n.d. (© Henri Cartier-Bresson. Courtesy Henri Cartier-Bresson/Magnum.)

45. Jeffrey Schwarz, Untitled, New Jersey, 1981. (© Jeffrey Schwarz. Courtesy the photographer.)

46. Alfred Eisenstaedt, *Penn Station Farewell,* New York, 1943. (Courtesy *Life* magazine/© Time Inc.)

47. René Burri, Untitled, South Korea, 1961. (© 1961 René Burri. Courtesy René Burri/ Magnum.)

48. Jim Goldberg, *Ice and Breeze in Squat, L.A.,* 1988. (© 1989 Jim Goldberg. Courtesy the photographer.)

49. Helen Levitt, Untitled, New York, from *In the Street.* (© 1940, 1987 Helen Levitt. Courtesy Fraenkel Gallery, San Francisco.)

50. Helen Levitt, Untitled, from *In the Street.* (© 1940, 1987 Helen Levitt. Courtesy Fraenkel Gallery, San Francisco.)

51. Garry Winogrand, *Texas State Fair,* Dallas, 1964. (© 1984 Estate of Garry Winogrand. Courtesy Fraenkel Gallery, San Francisco, and the Estate of Garry Winogrand.)

52. Richard Kalvar, Untitled, U.S.A., 1976. (© 1976 Richard Kalvar. Courtesy Richard Kalvar/ Magnum.)

53. Ruth Orkin, *Andy and Mary, Fire Island, NY,* 1965. (© Ruth Orkin. Courtesy Witkin Gallery, New York, and Mary Engel, Ruth Orkin Photography.)

54. André Kertész, *Gypsy Children,* Esztergom, Hungary, 1917. (© 1989 Estate of André Kertész. Courtesy the Estate of André Kertész.)

55. Ken Miller, *Marisa and Paul,* 1985. (© 1988 Ken Miller. Courtesy Harrison Sheppard.)

56. Dmitri Kessel, *Elder of Red Pepper Village with His Great-granddaughter,* China, 1946. (Courtesy *Life* magazine/© Time Inc.)

57. Jean Gaumy, Untitled, France, 1973. (© 1973 Jean Gaumy. Courtesy Jean Gaumy/Magnum.)

58. Willy Ronis, *Le Départ,* Fécamp, France, 1949. (© Rapho. Courtesy Willy Ronis/Rapho and Hyperion Press Limited.)

59. Elliott Erwitt, Untitled, California, 1955. (© 1955 Elliott Erwitt. Courtesy Elliott Erwitt/Magnum.)

60. Robert Doisneau, *Photographie Aérienne,* 1950. (© Rapho. Courtesy Robert Doisneau/Rapho and Hyperion Press Limited.)

A C K N O W L E D G M E N T S

MY THANKS to all the photographers, galleries, dealers, and collectors who helped to make the exhibition and this book possible. *S*pecial thanks to Catherine Chermayeff at Magnum Photos, Monah Getner at Hyperion Press, Debra Cohen at *Life* Gallery of Photography, Michael Lebeau, and Candice Fuhrman, who helped me find my way to Harmony. And *THANKS* to Vincenza Petrilli, whose assistance in putting it *all* together made the Kiss book and exhibition a lot more fun!

SPECIAL THANKS to Tom Robbins, for his generous contribution in making this more than just a feast for the eyes. At Harmony Books, thanks to Margaret Garigan, Peter Guzzardi, John Fontana, Teresa Nicholas, Laura Hammond, Mark McCauslin, Ed Otto, and Laurie Stark.

X X X